T0018377

Neshat-isms

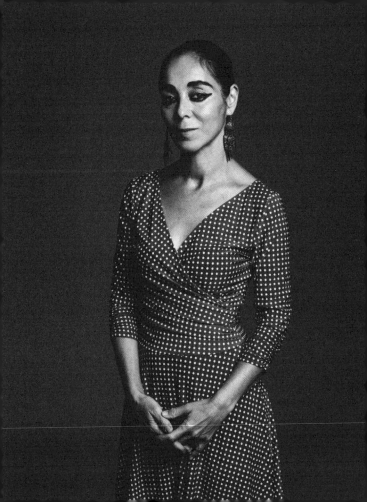

Neshat-isms

Shirin Neshat

Edited by Larry Warsh

PRINCETON UNIVERSITY PRESS
Princeton and Oxford

in association with
No More Rulers

Published by Princeton University Press,
41 William Street, Princeton, New Jersey 08540
In the United Kingdom: Princeton University Press,
99 Banbury Road, Oxford OX2 6JX
press.princeton.edu
in association with
No More Rulers
nomorerulers.com
ISMs is a trademark of No More Rulers, Inc.

ℙ PRINCETON ~~NO MORE RULERS~~ ®

All Rights Reserved

ISBN 9780691254630
Library of Congress Control Number 2023010095
British Library Cataloging-in-Publication Data is available

This book has been composed in Joanna MT
Printed on acid-free paper. ∞
Printed in China
1 3 5 7 9 10 8 6 4 2

CONTENTS

INTRODUCTION

In a polarized world, artists are among the rare individuals who tackle the things that divide us, finding unexpected commonalities and bringing us together with works of beauty and insight. And few artists achieve this as elegantly as Shirin Neshat. A keeper of culture and a rebel spirit, Neshat understands that art is a powerful agent of change. She is a brave woman and a confident artist who makes political realities a foundation of her aesthetic focus, unflinchingly and without hesitation.

Neshat was born in Qazvin, Iran, in 1957. An avid moviegoer in childhood, at seventeen she was sent to the United States to complete her education in Los Angeles, living first with her sister and then a French Jewish family there. Three

years later, in 1978, the Islamic Revolution began in Iran. Since then, Neshat has returned to her native country only three times, the last in 1995. "I am as American as I am Iranian," she has said.

After receiving and MFA from the University of California, Berkeley, in 1983, Neshat moved to New York. She became codirector of the Storefront for Art and Architecture on Manhattan's Lower East Side, working with architects like Zaha Hadid and Jean Nouvel. In 1992, she began her first photographic series, *Women of Allah* (1993–97). These works gained immediate art-world attention, effectively launching her career. A New Yorker for some forty years now, in 2017 Neshat left Manhattan's SoHo for Bushwick, Brooklyn. "I like Bushwick. It feels good to be back to a neighborhood of mainly immigrants and artists, like how I remember NY used to be when I first moved here and lived

in the East Village in the 1980s. It feels real and alive here."

Considering a move into film and video, in 1996 Neshat immersed herself in the intensive study of cinema, particularly Iranian productions. That year she made her first film, *Anchorage*, a commissioned work for the arts organization Creative Time, made to be shown at the base of the Brooklyn Bridge. Later films and installations—including *Turbulent* (1998), *Rapture* (1999), *Tooba* (2002), and *Women without Men* (2009)—were framed by the tensions and dynamics of contemporary Iranian society. Her 2017 feature film, *Looking for Oum Kulthum*—about the renowned Egyptian singer, songwriter, and actress—is "a film by a woman, about women," as she put it.

A partial list of the awards that Neshat has earned gives an indication of her impact over

her career to date: First International Prize at the Venice Biennale in 1999; the Hiroshima Freedom Prize in 2005; the Dorothy and Lillian Gish Prize, given to an individual who has "made an outstanding contribution to the beauty of the world and to mankind's enjoyment and understanding of life"; the Silver Lion for Best Director at the Venice International Film Festival in 2009; the Crystal Award from the World Economic Forum in Davos for contributions to the world through art in 2014; and the Praemium Imperiale Award, Tokyo, in 2017. In 2010 the *Huffington Post* named her Artist of the Decade, describing her art as "chronically relevant to an increasingly global culture" and noting that "the impact of her work far transcends the realms of art in reflecting the most vital and far-reaching struggle to assert human rights."

The themes that resound in so much of Neshat's work—loss of homeland, emigration, the dynamics of contemporary Iranian culture, the power of the female gaze—echo through the pages of this book as well. In quotes gathered from interviews, written works, and other primary sources, Neshat reflects on art, the creative process, resistance, change, and much more. In these challenging times, the integrity of her artistic vision—its unflinching honesty, resourcefulness, and fluidity—is an inspiration to us all.

LARRY WARSH
NEW YORK CITY
AUGUST 2023

Neshat-isms

Art

For me, art has been a way to escape
the everyday life; and find a deeper
meaning in life. (38)

———

I look to art to be moved, to be
deeply affected; almost like having
a religious experience. (5)

———

As an artist I'm not interested in pure
realism, but the poetics that can be found
in everyday life.

———

My work has always revolved around three
things, women, religion, and politics. (17)

———

I see my art as a tool for dialogue. (14)

———

My nature has been to rebel against my
own artistic signature. (21)

———

Political art is most effective when it's
not bias, it frames the issues but then allows
the audience to draw their own
interpretations. (77)

———

My work usually reflects back in time—it's
rarely about the present moment. (37)

———

I'm not satisfied with just explaining
my culture. I don't want to be an
ethnographic artist. (40)

———

No one in my family was artistic. I grew up
in a small town in Iran and had never visited
a museum or a gallery until I arrived in the
United States at the age of 17. In the culture I
was raised in, art was considered decoration,
or craft. There was no history of visual art or
visual artist as we understand it today.

———

I can easily claim that I was quite useless
in art school.

———

As a child, I had never been exposed
to any form of art or art history, other than
functional and decorative arts and crafts. (4)

———

When I look back at my education, it
wasn't successful partially because I was not
intellectually matured yet; partially because
my studies coincided with the 1979 Iranian
revolution; and mainly because my focus had
shifted so I could stand on my own two feet
as a young woman in a foreign country. (4)

———

My upbringing, and my interest as a young
child in art, and later my education in art,
have nothing to do with what I do today. (34)

———

From the very beginning, every work
I have done has been inspired by the words
of a writer. (9)

———

The reason why Rumi's poetry suits my work
is the ambiguity of his poems. I'm not a Rumi
expert, but there is always a question, an
openness, in his work, regarding the subject
of love. Whether it's divine love or human
love, and who he's talking to. (9)

———

I'm influenced by classic Islamic art, where the notion of beauty plays a great role, and has been defined as a mediator between humans and the divine. (21)

————

In all my work, I am dealing with ideas that address socio-political and historical issues; but in the end, I want my work to function on a visceral level. (5)

————

I never censor myself, but I do give myself a lot of boundaries. (37)

————

When I entered the art world with "Women of Allah," some people thought I was endorsing the Iranian government; the government thought I was criticizing them. And the Western critics thought I was simply being provocative. At that stage, I didn't even have a career yet. (50)

———

I've had to take a lot of pictures of guns, and the irony is that what can be threatening can also be very beautiful. (4)

———

I always depict beauty in the presence of horror, violence, and pain, never on its own. (21)

———

It's a mixed blessing when you make art that has an acute relationship with political ideas. On the one hand, it is provocative, sensational, often timely; on the other, the theme takes over the form, and the subject dominates the art. (39)

———

My work is always about mediating between knowledge, facts, and yet mystery and the unbelievable.

———

I'm very interested in people who live on that edge of sanity and insanity. Like artists! (1)

———

I feel most comfortable with surrealism—not only as a strategy to avoid the obvious but as a means to make art that transcends the specificities of time and place. (2)

———

Everything I make seems to be a fictionalized interpretation of history. (22)

———

My work is always dealing with some form of paradox. (55)

———

Everything that I have ever made, visually and conceptually, is created in some form of opposites; black/white, magic/realism, personal/social, local/global, piritual/political, mystical/violent, and masculine/feminine. (2)

———

For a long time, I tried to understand why so many dualities, but now I realize it's probably because I always personally feel so conflicted in between my inner and outer worlds, the Iranian and the American in me. (21)

———

It has been an interesting challenge to
negotiate a balance between the art world and
the political reality that very much informs
my work. I can say that I do my best to remain
true to my subjects and vision, regardless
of whether it will be commercially
pular or not. (36)

———

I have not been good at repeating myself.
I have a tendency to keep moving from
one form to another. (21)

———

Living in places that are too comfortable
is anticlimactic for artists. (39)

———

I am not big on international art destinations
like art fairs or art biennials. I would rather
explore the cultural spaces in countries that
are normally off the chart. (66)

———

I never thought of art as a career and a
way to make money. (80)

———

I don't think an artist should make a mark unless they have something compelling to say. I feel strongly that you cannot make work about a subject unless you have experienced it yourself. You can't make work about exile unless you have lived in exile. You cannot make painful art unless you have suffered. You cannot make political work if you haven't lived a political life. (77)

———

There have been some positive changes in the art world, for example, how someone like myself has been taken seriously in a field that is mostly dominated by white, male, Western artists. But at the same time, I feel that today, the contemporary art world is very much driven by the market and validates and invalidates art and artists according to their commercial value and success. So of course this is a pity, because art in the end is treated like a "business." (36)

———

Much of contemporary art is cross-disciplinary. Defined fields are vanishing as artists break the boundaries from one field to the next, borrowing from here and there to arrive at their visions. (16)

———

I think for too long art has been too isolated and exclusive. Now, with the breaking down of boundaries between media, artists are having the advantage of experimenting and approaching the popular culture and, consequently, a larger public. (28)

———

I've never been one of those artists who has been immediately accepted or embraced. (38)

———

My obsession tends to go to artists who have lived challenging lives. (30)

———

At art school, I was obsessed with Frida Kahlo—her paintings, her persona, her style, her relationship to Diego Rivera, her political life and friendship with Russian intellectuals. (22)

———

Cindy Sherman continues to inspire me as an artist and human being. (22)

———

Marina Abramović is an artist I love, respect, and look up to for her art, and endurance, for maintaining a fascinating and long career. (22)

———

I am a huge fan of William Kentridge, who never ceases to amaze me for his depth, poetry, and intelligence. (22)

———

From the start, my work has generally drawn
mixed reactions from Western art critics,
Iranian regime, and the Iranian people. Today,
after so many years of working, I understand
how my art will always remain controversial
and will always be interpreted differently
by different audiences. (22)

———

On one hand, although most of the
Iranians I know are not familiar with
contemporary art, they get the social, political,
and historical nuances of my ideas; while for
the Westerners, on the other hand, they
understand the contemporary art better, but
they can't quite grasp the complexity of
Iranian culture. (27)

———

The majority of Iranian people who live
in Iran don't have access to my work in
galleries and museums. The only thing they
really do have access to is my films because
the movies get disseminated through
internet and piracy. (25)

———

I see a future where art is far more integral
with social and cultural realities of the world.
(28)

———

Art will become more and more global
and interdisciplinary. (28)

———

When you're an artist who's been around for a while like I have, you understand that it's almost impossible to make work that is unanimously loved or understood! You can't please everyone, and that is a great realization. (3)

———

The nature of my work is ambiguous, so it draws a wide range of responses. Any viewer, Iranian or Westerner, will perceive the work depending on her or his own knowledge, political point of view, and experience to the subjects I raise. (16)

———

There is no way I can control what people take away from my work—the people take away what they want from it according to who they are. (35)

———

Art is about artists asking questions, but not providing answers. (13)

———

Film

I see filmmaking as the most complete form of art—it can incorporate photography, painting, choreography, music, performance, narrative, and much more. (51)

———

Music in my work is never a backdrop but expresses moods and emotions. (32)

———

I've found more potential in film and video than in still photography. I think there's ultimately a limit to how far you can go with photography, but that is not so with film. (28)

———

It was the language of cinema that excited me, the art of storytelling as opposed to creating images and concepts. (44)

———

All my concepts in my video installations
have been inspired by literature, mostly
poetry, sometimes novels. (33)

———

I always felt like if I wasn't a visual artist,
I would have been a poet. (80)

———

I think fiction is more truthful than reality. (57)

———

Through fiction we can go deeper into the
human psyche, deeper into reality, deeper into
the universal plight of what it's like to be a
human being on this planet today. (91)

———

I'm always interested in more allegorical,
surrealistic ways of storytelling. (23)

———

My ideas always start with a concept and slowly turn into stories. (60)

———

Editing is not something you can do in a rush because the artists themselves are not always their own best editors. (23)

———

Making movies is like moving a mountain. From writing a script, casting, and raising the funds, to the actual production challenges, editing and finally bringing it to an audience. The process usually takes many years, but it's absolutely worth it. (96)

———

It's almost unbelievable what it takes to make a movie. (34)

———

Even a 10-minute film can take me a year. (32)

———

Abbas Kiarostami has been a longtime idol of mine, and I was lucky to become his friend. I'm blown away by his clever yet simple approach to social realism, which on the surface seemed to capture the malice of Iranian culture, but, in reality, his vision was grander than his own country. (22)

———

Magical realism offers the freedom to escape reality, to delve into what may be unbelievable, yet truthful. Most importantly it allows one to navigate between our conscious and subconscious minds. (68)

———

The most recent film to have a big impact on me [in 2002] was *In the Mood for Love* by Wong Kar-Wai. An incredible piece of visual and cinematic poetry. I really appreciated how the director balanced beauty, style, and emotions in such a simple and subtle storyline. (28)

———

Andrei Tarkovsky has been hugely influential in my film work. I absolutely love his dreamy, poetic, philosophical, and highly politically charged narratives and visual style. (22)

———

I've always been inspired by Scandinavian cinema, master filmmakers such as Ingmar Bergman, Roy Andersson, and Ruben Ostlund. (22)

———

Jane Campion's films are moving, well crafted, beautifully shot, and always have powerful performances. She takes her time to make films. (29)

———

Most of the Iranian community I know, inside and outside of the country, rarely go to museums or galleries to see my work, but they will go to the cinema. (33)

———

As visual artists, we have a lot of freedom in our expression and use of medium, but ultimately it's the market that defines whether our art is good or bad. My experience in the film world has been very different, I may not have as much freedom, but making money has never been part of the equation. I have made films purely because of my love and passion for the form. (65)

———

We're beginning to see more women, people of color, and other minorities, onscreen and behind the scenes, which is wonderful. However, this trend may be too superficial and too short-lived, so I see the only solution being that we continue to challenge the mainstream by the quality of our work and talents so that it will be impossible for anyone to reduce us to the color of our skin or our ethnicity. (29)

———

The film world has always been predominately a male-dominated business. (24)

———

If a man wants to make a movie, he just leaves the kids to his wife. However, the wife will have the problem if she wants to make a film. (64)

———

It amazes me to see what some actresses have to go through in order to make it in Hollywood, or how few films by female directors see the light of day. (24)

———

Looking for Oum Kulthum is a film by a woman, about a woman. So, while the film can be criticized for all sorts of reasons, it is unique in its total and uncompromising feminist point of view. (24)

———

An artist like Oum Kulthum is only born once in a century. (24)

———

I never intended to portray my female characters as victims or losers. Rather, I wanted to show how while such women are against the wall and live under tremendous oppressive situations due to traditional and religious pressures, they are always defiant, resilient, and rebellious. (2)

———

While photography is about capturing a single moment, creating an image that conveys the full story; filmmaking is about telling a story, enhanced by a mood that is created through use of space, performance, camera, music, sound design, etc. (28)

———

Space has been a particularly important aspect of my work, as it helps define the narrative by setting up the mood, the character, and the historical and political backbone of a story. (21)

———

Architecture has been above design for me, it has been a way to define cultural social, political, religious, even ideological narratives.
(27)

———

As much as I wish to remain in the art world, I'm very happy to be equally active in the film world. I don't see why you can't do both. (33)

———

I still feel like a beginner as a filmmaker. (27)

———

Process

Failure is a fundamental aspect of the
artistic process. (27)

———

I truly prefer being on that edge of failure
than the risk of repeating myself. (25)

———

There's nothing worse than mediocrity. (80)

———

I have made some bad and mediocre work,
but it has kept me on the edge to continue
to challenge myself and be a beginner and
learn new languages of artistic nature.
Failure is something to embrace and
not be ashamed of. (35)

———

I like the challenge of being a beginner;
the excitement of not knowing exactly what
I'm going for, and whether or not the
outcome would be any good. (83)

———

I didn't make any work for ten years after
graduating from art school. I was smart
enough to know that I had nothing to
contribute to the art world and
mediocracy was futile. (89)

———

You have to live a meaningful life and
take risks outside of school. (89)

———

Living in your imagination means you connect to an internal world that is so vast and wonderful. In that state everything is possible. All boundaries turn into a source of joy and creativity. (40)

———

I don't ever want to get to a place where I feel like I have "arrived," that I know exactly what I'm doing and will go on to repeat it. (25)

———

It is very important for me that while my work is politically charged, its impact is emotional. (34)

I consider art as a form of communication, as a way to have emotional and intellectual impact on people without having any specific political or ideological agenda. (91)

———

The biggest challenge for any artist is how to frame issues that feel urgent yet allow a sense of timelessness. (58)

———

You can't demystify a myth. (3)

———

I am never loyal to any mediums for very long. I believe in experimenting and taking my risks. (9)

———

I'm not trained as a photographer or as a
video artist. I didn't study filmmaking or
opera. Everything I've ever made so far has
been a process of embracing a new medium,
educating myself, then trying to find
my place within that art form. (83)

———

I instinctively follow what I believe should
be a natural progression for my ideas and
experimentations. Every project, in whatever
form, turns into an exercise of pushing
my boundaries further so I can arrive
somewhere fresh. (52)

———

My work is deeply personal but not
autobiographical. (97)

———

The projects I choose are often overly
ambitious and feel impossible at times. (39)

———

There is nothing wrong with failure. You fail
or fall, and then you pick yourself up again…
that is what really counts in the end. (27)

———

The most important thing is to be self-critical.
(71)

———

Regardless of how gratifying or painful
it may be, every artist needs reactions,
feedback, and interpretations. (83)

———

Stay confident and keep pushing forward—all you need is to find one or two people who believe in you and will have your back. (29)

———

The tendency of the audience is to define you within a certain artistic signature, and then you yourself get accustomed to that identity, therefore keep repeating yourself. It takes a lot of courage to break out of your own mold. (1)

———

I have a fundamental problem with the notion of a "comfort zone," the idea that I am a mature artist with a signature style that is appreciated and, therefore, I can afford to elaborate on that until I die. (25)

———

I've learned to work nomadically, which is probably the only positive advantage of being a self-exiled artist. (21)

———

I have worked in Morocco, Egypt, Turkey, Azerbaijan, Mexico. I go everywhere to make-believe it's Iran. (8)

———

I don't think I will ever enjoy working alone in a studio as much as getting out in the world, seeking adventures, exploring new locations and communities. (94)

———

My most successful works are the ones that
need no translation and can be open to
multiple interpretations. (4)

———

I have always worked collaboratively—I enjoy
having someone to brainstorm with and go
through the artistic journey together. I've
never been a traditional studio artist. (39)

———

I see a pattern of finding "muses," or
rather other women who become
my extension. (42)

———

Once you get involved with teamwork, it is automatically a collaborative process. It teaches you how to navigate around other people's artistic and professional tendencies. (73)

———

My still photography has been mainly human portraiture, highly minimal, composed, stylized, and sculptural. (16)

———

Every time you get to work with a new collaborator, it's like dancing with a new partner. (9)

———

Making art that involves collaboration
with non-professionals, you learn to
expose yourself in a way you rarely do,
and consequently a wonderful human
interaction takes place. (94)

———

I find human body, human expression
endlessly interesting regardless of how many
times it's been captured in time. (25)

———

What I find fantastic about human portraiture
is that it can take ordinary people and turn
them into monuments. (37)

———

There is a severity in black and white
that I like, and in general I find color too
seductive and distracting. (22)

———

I will never, ever make any work that
ends on a dark note. (93)

———

My approach to still photography has
become more and more narrative. I can no
longer make single images that function on
their own; rather a series of images that
together tell a story. (37)

———

Poetry has always been an important part
of my work, it adds context, depth,
and emotions. (37)

———

I am very conscious of both averting the ideas
of stereotypes while playing with them. (27)

———

I tend to always work around some notion of
opposites both in form and content. (35)

———

I'm quite clear about my work's intentions,
but once out in the world, I cannot control
people's perceptions. (27)

———

Identity and Self

My destiny has been a product of a revolution
that had defined the course of my life. (22)

———

Every Iranian artist, in one form or another,
is political. (8)

———

I speak with the voice of an artist,
not a political activist. (87)

———

If it was not for my personal difficult
political circumstances, perhaps I
wouldn't be an artist. (21)

———

I see the role of an artist as a communicator.
(15)

———

My work is a conversation between my
inner and outer worlds; a response to the
ife and the world that I inhabit. (70)

———

Every concept, every character, every narrative
in my photographs, video installations, and
movies has stemmed from issues that I have
faced as a human being, as a woman and
as an Iranian. (97)

———

The most effective art, in my opinion, is that which is ethnically specific while tackling universal issues. (83)

———

While my themes relate to Iran, my artistic tools are very Western. I have been educated in the West and have lived longer in the United States than in my own country, therefore my vision as an artist has been shaped by all forms of influences, travels, and ultimately a life in the diaspora since a young age. (83)

———

I feel that emotionally my foundation remains totally Iranian, while my lifestyle and character is that of an American. (93)

———

My work has always been a way of
bridging my inner and outer worlds.
My emotions, including my personal
angst with a world that goes above and
beyond my small existence. (96)

———

I have never been a believer that artists
are born talented. Rather, artists develop as
they respond to the world they inhabit
and the life they live. (89)

———

My journey as an artist started as a way to explore my own personal dilemma and relationship to my country but somehow it has turned into a fictionalized narrative of my country's history. (89)

———

There is something wonderful about activism, to forget about yourself…to do things that are for the benefit of others. It's healthy for us as artists. (33)

———

I don't see my work as a product of special talent, but rather as a product of a person with specific experiences and a certain point of view. (28)

———

I am myself full of contradictions: strong, confident, and rational, and yet fragile, vulnerable, and mad. (21)

———

Every work that I've made so far seems to have been drawn from something personal, or at least driven by subjects that have related to my own individual circumstances, dilemma, and anxieties, [and] as a human being. (22)

———

Dark times and melancholy can be a point of self-reflection. (38)

———

Being an artist takes a lot of character. The art world is super competitive and intimidating, so it takes a lot of guts to survive it. But my skin has grown tough over the years! (35)

———

There is a saying, you can take an Iranian out of Iran, but you can never take Iran out of an Iranian. (6)

———

I have no problem with the religion of Islam and I myself was raised as a Muslim; but I believe in separation between religion and state. (65)

———

I think life could be more meaningful if we [could] find the compassion to open our minds and our eyes to other people's issues and see if we can expand our love and care for people beyond our immediate family. (7)

———

It would be a generalization to speak about Islam as a whole. My work has only addressed Islam in relation to my country Iran, and the government's use of religious rhetoric to enforce its ideology, particularly on the women. (5)

———

The female body has been a potent,
controversial, and highly problematic issue
in my culture in Iran. (84)

———

The female body has been central to my
work in many ways, as the notion of shame,
sin for arousing desire and sexual temptation;
as a battlefield for political, religious, and
ideological rhetoric; and as an
object of violence. (4)

———

Historically in Iran, the female body has been used as a platform for men's political agendas. In the 1940s Reza Shah forced the women to unveil; and later, following the 1979 revolution, Khomeini enforced mandatory veiling. (26)

———

In many ways the female characters in my work are extensions of myself. (93)

———

In many ways by studying the lives and condition of Iranian women, one can grasp a good understanding of the Iranian society today. (90)

———

As my palette gets bigger and I work with different forms, I have gained a broader audience, but also feel a greater pressure and responsibility. (22)

———

Never take praise or criticism too seriously. (33)

———

In our culture, in the absence of freedom of expression, the use of metaphoric poetic language has been a way of life; the only way of expressing oneself. Persian poetry is often subtle but deeply political, and the public learns to read between the lines. (52)

———

The relationship of Iranian people to literature is very profound and central to them. I remember how as young students, we memorized poetry; and how in social gatherings, everyone expressed their views about life, politics, and history through exchanging lines of poetry. (13)

———

Iran is a country of paradox, a country known today as a dangerous dictatorship, yet also known as one of the richest cultures in the history of mankind with great ancient mystics and poets such as Rumi, Hafiz, and Khayam, as well as contemporary activists, writers, and filmmakers, etc. (93)

———

To this date my art evolves according to my own emotional, psychological, and political circumstances and yet always expands beyond my life and turns into a dialogue about the world I live in. (97)

———

We all dream. Dreams are innocent and cannot be judged. And it's through dreams that we find a shared humanity, where we're completely naked, free, vulnerable, and here we face our worst fears and anxieties. (22)

———

It's only in dreams that we are mostly truthful.
(23)

———

Dreams are where our fears live. (19)

———

[By being] an artist, by getting closer to other
people's pain, you cope with your own. (19)

———

I would like to be remembered as an
artist who became a narrator of history
in fictional form. (22)

———

If the clock stops right here, I feel that
I have achieved a great amount
of my dreams. (10)

———

Politics doesn't seem to escape people like me.
(8)

———

We Iranians are survivors, and I am
one of them. (96)

———

Belonging

I am as American as I am Iranian. (53)

———

I've never been able to stay anyplace very long.
My nature is nomadic. (9)

———

I think that nomadic is a better word
than exile. (34)

———

Making art was a way of maintaining
a connection with my country. (19)

———

I always feel like an outsider both
within the Iranian community and the
Western culture. (96)

———

As long as I'm Iranian, the work
will be Iranian. (93)

———

My life is defined by political reality.
The revolution separated me and my family.
(35)

———

We Iranians have lived in a constant state
of fear inside and outside of Iran for
nearly 44 years. (23)

———

If I went back to Iran, I'm not sure if I
would really feel part of that society anymore.
So maybe I've lost that idea of home forever.
(37)

———

It's been my experience that any successful
Iranian artist living in the diaspora often faces
some degree of suspicion and criticism by his
or her community who questions the artist's
integrity and authenticity. Hopefully with
time that changes. (85)

———

The world seems to mainly remember Iran after the Islamic Revolution. (48)

———

We grew up in Iran fantasizing about the image of America as the "land of dreams," where dreams come true! (57)

———

What Iranian people have been frustrated by is not the religion of Islam, but a dictatorship that uses religion to oppress and silence its own people. (72)

———

My work has only addressed Islam in relation to my own country Iran, and not the entire Muslim world. Islam is practiced vastly differently in various Muslim cultures. I was born in a country that was once a secular Muslim society, but sadly now is ruled by fanaticism of a government that imposes strict religious rules on the people. (45)

———

I have never claimed or wished to be the voice of the women of Iran or the people of Iran. I make art that is inspired by Iranian culture, Iranian people, especially Iranian women. (83)

———

Although often my work relates to Iran,
I hope it transcends Iranian culture and
has a universal resonance. (84)

———

Sometimes I think I have lost all desire
to go back to Iran. (22)

———

I can't imagine living in a place where I'm
always under surveillance; I'm told how to
dress, how to behave, how to live. (45)

———

After years of working on subjects
related to Iran yet not being able to go back,
I decided to end this period of nostalgia
and turn my lens to America, a country
where I have lived longer than my own
but never tried to capture. (97)

———

I had never felt like I had the license to talk
about America or make art about America
since I wasn't born there. (97)

———

The New York underground art scene became
my haven, what allowed me to persevere. (80)

———

I like living in Bushwick, a neighborhood full of hard-working immigrants and artists. It's chaotic, messy, and often dirty but full of life and real. (39)

———

Once I leave New York, I am immediately reminded that I am an immigrant, but here I really feel at home. (70)

———

New York has become too clean-cut. The whole notion of bohemia doesn't really exist here anymore. (39)

———

I like places that are rough, loud, crazy, chaotic, down-to-earth. (39)

———

America is a country that offered me
a home, safety, and the opportunity to
become who I am. (97)

———

There's something very powerful
and mystical about nature, a reminder of
our fragility as humans. (23)

———

We're either awake or we're sleeping. When
awake, we work hard at shielding ourselves
from all that worries us; but when sleep all
our fears and anxieties visit us. (23)

———

Dreams are innocent. (10)

———

I'm a nomad, I will never completely
belong to anywhere. (96)

———

Resistance

Art is our weapon. Culture is a form
of resistance. (8)

———

It's quite rewarding to know that art could
be a source of threat to the order of an
oppressive regime. (13)

———

If you stay silent, you are complicit in
what is happening. (11)

———

If anyone is going to overthrow the current
[Iranian] government, it's the Iranian women.
(12)

———

The frustration and rage of the Iranian people
have been brewing for a long time. (17)

———

It takes 20–30 years, or more sometimes, to build up that kind of rage and determination to bring about a revolution. (45)

———

Women of Iran are fearless regardless of generation. (26)

———

Ever since the 1979 Revolution, a woman's body has turned into a battlefield for the Islamic Republic's political, ideological, and religious rhetoric; it is as if losing control of Iranian women would mean losing control of the whole society. (86)

———

My female characters have been women who are in vulnerable positions, who live under oppressive climates but are always defiant, resilient, and courageous. And this is how I feel about Iranian women across generations. (83)

———

In Iran, the women are the most rebellious ones because they are most against the wall. (34)

———

Women living in extremely oppressive cultures tend to be extraordinarily resilient and powerful. (9)

———

I believe that everything that I've made so
far has been consistently about women
who confront power. (83)

———

This time [the popular uprising] is not about
the economy, unemployment, or water—it is
about women. And women are a very
sacred part of society. (17)

———

I've always done a lot of work about women
in a state of madness, where ultimately,
they find a kind of freedom. (1)

———

I see my art and activism as two separate
things. In my art I'm not biased but in
my activism I am biased. (14)

———

Artists come from the core of the society,
therefore they can talk about the people
and to the people. (83)

———

If an artist has a certain power to be heard
or to voice something important, then then
it's necessary to be vocal. (92)

———

I tend to consider an artist to be a conduit, and art and culture to be a bridge between people and the people in power. (91)

———

Poetic, metaphoric language allows Iranian artists to express all that is not allowed to be expressed; to be subversive without breaking the law. (88)

———

Artists have been central to the cultural, political, social discourse in Iran. We are there to inspire, to provoke, to mobilize, to bring hope to our people. We are the reporters of our people, and the communicators to the outside world. (8)

———

Who would have thought that one day, an American president like Trump would share values with Iranian spiritual leaders? (22)

———

As an Iranian American, I'm amazed by how few Americans are aware of their own country's intervention in Iran and how we Iranians wouldn't be here today in our history had it not been for the CIA's overthrow of our democratically elected prime minister Dr. Mossadegh. (43)

———

Americans had everything to do with this transformation of [Iran] from a secular to a fundamentalist society. (44)

When we say that we must keep our "Eyes on Iran," we mean that what's happening deserves not only our attention but our solidarity. (18)

The world has been going through such a difficult time, between the pandemic, the war in Ukraine, the rise of conservatism, nothing makes sense. What makes this time different is [that] our anxieties are now collective anxieties. People, for the first time, have realized we have a shared pain. We're just conditioned to different cultures and regimes and political systems. (46)

———

I envy sometimes the artists of the West
or their freedom of expression. For the fact
that they can distance themselves from the
question of politics. From the fact that
they are only serving one audience, mainly
the Western culture. But also, I worry about
the West, because often in this country, in this
Western world that we have, culture risks
being a form of entertainment. (8)

———

Iranian people don't share the same value
of freedom of expression as Americans, so we
are accustomed to the use of metaphor and
allegory to express all that cannot be
expressed otherwise. (21)

———

Forty years of living under dictatorship, censorship, and lack of freedom of expression has hit the creative community hard. Some artists tend to self-censor their own work, others constantly battle with the regime and face arrest and imprisonment, while others like myself and thousands of other artists simply leave the country. (76)

———

I have never thought of myself as a political artist but nevertheless my name and work continue to be a problem in Iran. (22)

———

As long as this government is in power;
there is no possibility my work could go
on public display in Iran. (51)

———

Censorship, harassment, arrest, and
imprisonment is a way of life for Iranian
artists or intellectuals who dares to cross the
boundaries and breaks the codes. (68)

———

I'm one of those people who feels that censorship has a certain silver lining. Limitations, like inhospitable climates that produce some of the most robust vegetation, often propel an artist to more vigorously exercise his or her creative energies. The acrobatics of having to circumvent, outwit, and elude the censor has succeeded in producing vigorous, sophisticated works of art. (16)

Artists are not biased. We don't have an agenda. That's why we are able to tap into people's emotions and minds in the way that no diplomat can. (83)

———

I think as artists we need to be politically conscious, but don't necessarily have to make political art or to be activists. (7)

———

As an activist, you have to distinguish between what is right and what is wrong. As an artist, you let the audience decide. (93)

———

My work has been about Iranian women living under difficult and oppressive political situations, but always powerful, defiant, resilient, and rebellious. (21)

———

People should be free to choose what they want to do with their lives, what they want to wear, what religion they want to believe in; this is not something a government or a community should impose. (72)

———

Freedom is so fundamental in one's life, no government should have the power to choose how one should live, behave, or to dress. (72)

———

Many artists, including myself, would rather not be politically vocal. And yet we are in a position where our voice counts and we must support the people who don't have a voice.

(17)

———

Art is no crime. It is every artist's responsibility to make art that is meaningful, that questions tyranny, that questions injustice. It is the artist's task to advocate change, peace, and unity. (91)

———

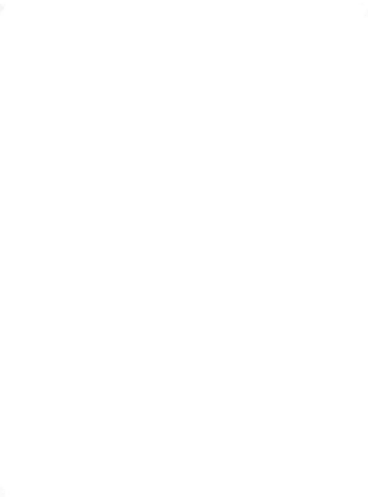

SOURCES

The quotes included in this publication have been lightly edited by
the author.

1. Wolfe, Shira. "Land of Dreams—Interview with Shirin
 Neshat." *Artland Magazine.* https://magazine.artland.com
 /shirin-neshat-land-of-dreams/.

2. Heartney, Eleanor. "Shirin Neshat: An Interview." *Art in
 America.* June 16, 2009. https://www.artnews.com/art-in
 -america/features/shirin-neshat-62800/.

3. Bogdan, Ana. "Shirin Neshat: 'You can't demystify a myth.'
 " *The Talks.* https://the-talks.com/interview/shirin
 -neshat/.

4. Enright, Robert, and Meeka Walsh. "Every Frame a
 Photograph: Shirin Neshat in Conversation." *Bordercrossings.*
 March 2009. https://bordercrossingsmag.com/article
 /every-frame-a-photograph-shirin-neshat-in-conversation.

5. Danto, Arthur C. "Shirin Neshat." *Bomb.* October 1, 2000.
 https://bombmagazine.org/articles/shirin-neshat/.

6. Neshat, Shirin. "Interview with Shirin Neshat—Meet
 the Artist." Farhang Foundation. October 17, 2019.
 Video, 7:17. https://www.youtube.com/watch?v=
 -FYX_EiFWW8.

7. Neshat, Shirin. "Shirin Neshat Interview: Advice to the Young." Produced by Marc-Cristoph Wagner, edited by Klaus Elmer. Louisiana Channel. March 2018. Video, 6:37. https://channel.louisiana.dk/video/shirin-neshat-advice -to-the-young.

8. Neshat, Shirin. "Art in Exile." TED Talk. May 2011. Video, 10:44. https://www.ted.com/talks/shirin_neshat_art _in_exile.

9. Khazeni, Dorna. "An Interview with Shirin Neshat." *Culture*, August 1, 2003. https://culture.org/an-interview-with -shirin-neshat/.

10. Loos, Ted. "Art That Is Political and Personal." *The New York Times*, September 12, 2019. https://www.nytimes.com /2019/09/12/arts/shirin-neshat-artist.html.

11. Roxborough, Scott. "Filmmaker Shirin Neshat on the Parallels Between 'Land of Dreams' and Current Events in Afghanistan." *The Hollywood Reporter*, September 3, 2021. https://www.hollywoodreporter.com/movies/movie -features/filmmaker-shirin-neshat-land-of-dreams-movie -afghanistan-1235007813/.

12. Neshat, Shirin. "Shirin Neshat Interview: Constant Reminders of Pain." Produced by Marc-Cristoph Wagner, edited by Klaus Elmer. Louisiana Channel. March 2018. Video, 34:03. https://channel.louisiana.dk/video/shirin -neshatconstant-reminders-of-pain.

13. Copeland, Colette. "I Will Greet the Sun Again: A Conversation with Shirin Neshat." *Glasstire*, February 27, 2021. https://glasstire.com/2021/02/27/i-will-greet-the-sun-again-a-conversation-with-shirin-neshat/.

14. Zivancevic, Nina. "Interview with Shirin Neshat in Paris." *A Gathering of the Tribes*. https://www.tribes.org/web/2008/05/26/interview-with-shirin-neshat-in-paris-by-nina-zivancevic.

15. Rea, Naomi. "To Portray America's Diversity in the Age of Polarization, Shirin Neshat Went to New Mexico to Photograph One of Its Poorest States." *Artnet News*, February 26, 2020. https://news.artnet.com/art-world/shirin-neshat-land-of-dreams-interview-1785786.

16. Sheybani, Shadi. "Women of Allah: A Conversation with Shirin Neshat." *Michigan Quarterly Review* 38, no. 2 (Spring 1999). http://hdl.handle.net/2027/spo.act2080.0038.207.

17. Kasiske, Andrea. "Shirin Neshat: 'The biggest uprising since the Islamic revolution.'" *DW*, October 28, 2022. https://amp.dw.com/en/shirin-neshat-the-biggest-uprising-since-the-islamic-revolution/a-63587780.

18. Dorris, Jesse. "For Freedoms Keeps the Iranian Fight for Liberation in Plain Sight." *Surface*, December 1, 2022. https://www.surfacemag.com/articles/for-freedoms-eyes-on-iran-new-york-miami/.

19. Neshat, Shirin. *Here and Now*. By Deepa Fernandes. WBUR, November 18, 2022. https://www.wbur.org/hereandnow /2022/11/18/shirin-neshat-iran-protests.

20. Batty, David. "Iranian Artists Call for Boycott of Cultural Institutions with Links to Regime." *The Guardian*, November 28, 2022. https://www.theguardian.com/world/2022/ nov/28/iranian-artists-call-for-boycott-of-cultural -institutions-with-links-to-regime.

21. Neshat, Shirin. "Shirin Neshat." In *Portrait of an Artist*, edited by Hugo Huerta Marin, 180–197. Munich: Prestel, 2021.

22. Lowry, Glenn. "Collecting Dreams: Shirin Neshat in Conversation with Glenn Lowry." In *I Will Greet the Sun Again*, edited by Ed Schad, 74–79. Los Angeles/Munich: The Broad and Delmonico Books, 2019.

23. Weiss, Haley. "In Dreams." *Interview Magazine*, August 18, 2016. https://www.interviewmagazine.com/art/shirin -neshat.

24. Riaz, Schayan. "The Many Faces of Oum Kulthum." *Qantara*, June 18, 2018. https://en.qantara.de/content/interview -with-iranian-artist-shirin-neshat-the-many-faces-of-oum -kulthum.

25. Julien, Isaac. "Artist Shirin Neshat on Experimentation and Ambition." *Financial Times*, September 3, 2021. https://

www.ft.com/content/9245d7f7-f587-4f8b-8074
-3c9f73180c5d?shareType=nongift.

26. Raptopoulos, Lilah. "Artist Shirin Neshat on the Women-led Protests in Iran." *Financial Times*, October 15, 2022. https://www.ft.com/content/30c9742e-df58-4c5f -8d3c-e12a93ffccb2.

27. Becker, Carol, and Phong Bui. "Shirin Neshat with Carol Becker and Phong Bui." *The Brooklyn Rail*, September 2009. https://brooklynrail.org/2009/09/art/shirin-neshat-with -carol-becker-phong-bui.

28. Shapiro, David, and Jasper Pope. "Shirin Neshat." *Museo Magazine*, 2002. https://www.museomagazine.com /SHIRIN-NESHAT.

29. Greenleaf, Sarah. "Tribeca 2022 Women Directors: Meet Shirin Neshat—'Land of Dreams.'" *Women and Hollywood*, June 9, 2022. https://womenandhollywood.com/ tribeca-2022-women-directors-meet-shirin-neshat-land -of-dreams/.

30. Neshat, Shirin. "Shirin Neshat on Why Frida Kahlo Is One of Her Favourite Artists." *The Art Newspaper*. February 26, 2020. Podcast, video, 2:00. https://www.theartnewspaper. com/2020/02/26/shirin-neshat-on-why-frida-kahlo-is -one-of-her-favourite-artists.

31. Dawson, Amy. "'This US Government Looks More Like Iran's Every Day': Shirin Neshat Talks about the Power of Political Satire Ahead of LA Show." *The Art Newspaper*,

October 18, 2019. https://www.theartnewspaper.com/2019/10/18/this-us-government-looks-more-like-irans-every-day-shirin-neshat-talks-about-the-power-of-political-satire-ahead-of-la-show.

32. Dannatt, Adrian. "Interview with Shirin Neshat: Where Madness Is the Greatest Freedom." *The Art Newspaper*, May 31, 2001. https://www.theartnewspaper.com/2001/06/01/interview-with-shirin-neshat-where-madness-is-the-greatest-freedom.

33. Miller, Iain. "Interview with Shirin Neshat: 'For Iranian Artists, Being Silent Is Like Taking the Side of the Demon.'" *The Art Newspaper*, May 31, 2010. https://www.theartnewspaper.com/2010/06/01/interview-with-shirin-neshat-for-iranian-artists-being-silent-is-like-taking-the-side-of-the-demon.

34. Lee, Christine. "Iranian Artist Shirin Neshat on Art, Politics, and Changing the World—Interview." *Art Radar Journal*, March 1, 2014. https://www.galeriey.com/2014/03/01/iranian-artist-shirin-neshat-on-art-politics-and-changing-the-world-%E2%80%93-interview/.

35. Neshat, Shirin. "Iranian-Born Artist Shares How Failure and a Beginner's Mindset Shaped Her Career." *Brigham Young University*, March 18, 2021. https://cfac.byu.edu/lectures/iranian-born-artist-shares-how-failure-and-a-beginners-mindset-shaped-her-career/.

36. Hegert, Natalie. "The Home of My Eyes: An Interview with Shirin Neshat." *Mutual Art*, March 18, 2015. https://www.mutualart.com/Article/The-Home-of-My-Eyes--An-Interview-with-S/F816E4D46DBB868D.

37. McNay, Anna. "Shirin Neshat: 'Nothing Is More Powerful than Human Expression.'" *Studio International*, April 23, 2015. https://www.studiointernational.com/shirin-neshat-interview-home-of-my-eyes-yarat-baku-azerbaijan-photography.

38. Roxo, Alexandra. "A Conversation with Shirin Neshat." *Hammer and Nail*, November 16, 2010. https://www.hammertonail.com/interviews/a-conversation-with-shirin-neshat-women-without-men/.

39. Shafaieh, Charles. "Day in the Life: Shirin Neshat." *Kinfolk*, no. 29 (September 4, 2018): 74–83.

40. Heartney, Eleanor. "Shirin Neshat: Living between Cultures." In *After the Revolution: Women Who Transformed Contemporary Art*, edited by Eleanor Heartney, Helaine Posner, Nancy Princenthal, and Sue Scott, 230–251. Munich: Prestel, 2007.

41. Khanjani, Ramin S. "Beyond Biopic: An Interview with Shirin Neshat." *Mubi*, October 10, 2017. https://mubi.com/notebook/posts/beyond-biopic-an-interview-with-shirin-neshat.

42. Yerebakan, Osman Can. "Shirin Neshat and Sheila Vand Spent Quarantine Going Beyond Reality's Borders in a New Feature Film Anchored Project." *Cultured*, March 10, 2021. https://www.culturedmag.com/article/2021/03/10/shirin-neshat-and-sheila-vand-spent-quarantine-going-beyond-realitys-borders-in-a-new-feature-film-anchored-project.

43. Cole, Susan G. "Interview: Shirin Neshat." *Now Toronto*, March 31, 2010. https://nowtoronto.com/movies/news-features/interview-shirin-neshat.

44. Harris, Brandon. "Shirin Neshat, *Women Without Men*." *Filmmaker Magazine*, May 5, 2010. https://filmmakermagazine.com/8023-shirin-nestat-women-without-men/#.Y4p8guzMI-Q.

45. Shammaa, Raphael. "A Conversation with Shirin Neshat." *American Suburb X*, February 15, 2014. https://americansuburbx.com/2014/02/interview-shirin-neshat-conversation-2014.html.

46. Wally, Maxine. " 'Iranian People Need Solidarity,' Shirin Neshat on Defiance and Hope in Iran." *W Magazine*, September 27, 2022. https://www.wmagazine.com/culture/artist-shirin-neshat-iran-protests.

47. Horsburgh, Susan. "The Great Divide." *Time*, August 28, 2000. http://content.time.com/time/world/article/0,8599,2050235,00.html.

48. Bertucci, Lina. "Shirin Neshat." *Flash Art*, April 25, 2016. https://flash---art.com/article/shirin-neshat/.

49. Neshat, Shirin. "Humanitas: Shirin Neshat at the University of Oxford, Lecture." Institute for Strategic Dialogue. May 18, 2012. Video, 59:56. https://www.youtube.com/watch?v=pySIgzyDvKk.

50. Ure-Smith, Jane. "Shirin Neshat in Washington and Baku." *Financial Times*, April 24, 2015. https://www.ft.com/content/9543d79e-e828-11e4-894a-00144feab7de.

51. Scardi, Gabi. "Interview to Shirin Neshat." *Domus*, March 18, 2010. https://www.domusweb.it/en/art/2010/03/18/interview-to-shirin-neshat.html.

52. MacDonald, Scott, and Shirin Neshat. "Between Two Worlds: An Interview with Shirin Neshat." *Feminist Studies* 30, no. 3 (Fall 2004): 620–659.

53. Neshat, Shirin. "Shirin Neshat Opens Up about Her Political Philosophy and Art." TRT World. April 15, 2022. Video, 26:20. https://www.youtube.com/watch?v=fJEhskukdF0&t=144s.

54. Neshat, Shirin. "Interview." Cineuropa. 2017. Video, 5:21. https://cineuropa.org/en/video/333821/rdid/331978/.

55. Scott, Carrie. "Interview: Shirin Neshat." Concept by Carrie Scott and Nick Knight, edited by Raquel Couceiro. Showstudio. April 27, 2018. Video, 26:52. https://www

.showstudio.com/projects/in_your_face_interviews/
shirin_neshat?tag=Contemporary%20Art.

56. Neshat, Shirin. "Shirin Neshat on Telling Complex Stories through Art." *CNN Style*, February 15, 2021. https://www
.cnn.com/style/article/shirin-neshat-personal-essay-art
/index.html.

57. Ongley, Hannah. "Shirin Neshat's 'Land of Dreams' Is an Absurdist Journey into Our Subconscious Minds." *Document Journal*, February 2, 2021. https://www.documentjournal.
com/2021/02/shirin-neshats-land-of-dreams-is-an
-absurdist-journey-into-our-subconscious-minds/.

58. Neshat, Shirin. "The Future of Art According to Shirin Neshat." Directed by Antony Crook. Artsy. January 28, 2021. Video, 3:08. https://www.artsy.net/article/artsy
-editorial-future-art-shirin-neshat.

59. Zaya, Octavio. "Q+A: Shirin Neshat." *Creative Camera* (October/November 1996).

60. Dalal, Pradeep. "Thoughts in Exile: Shirin Neshat." *Ego* (Winter 2005): 47–53.

61. Workman, Michael. "Artist Shirin Neshat, in conversation about art and life." *Chicago Tribune*, March 24, 2017. https://www.chicagotribune.com/entertainment/ct
-shirin-neshat-mca-talk-ent-0328-20170324-story.html.

62. Zaya, Octavio. "Shirin Neshat." *Interview Magazine* (September 1999): 165–166.

63. Saad, Shirine. "Exodus." *City Magazine* (2011): 46.

64. Anderson, Ariston. "Venice: Shirin Neshat Calls for Support for Women Filmmakers Amid Male-Dominated Fest Lineup." *The Hollywood Reporter*, September 6, 2017. https://www.hollywoodreporter.com/news/general-news/venice-shirin-neshat-talks-support-women-filmmakers-lack-female-directed-movies-at-fest-1035924/.

65. Valdez, Amanda. "In Conversation with Shirin Neshat." *Dossier*, no. 7 (2011): 22–25. https://www.dossierjournal.com/shirin-neshat.

66. Wyma, Chloe. "22 Questions for Shirin Neshat." *Artinfo*, February 6, 2012.

67. Langmuir, Molly, and Trish Deitch. "Elle Women in Art: Who to Know, Love, Collect." *Elle Magazine*, November 16, 2017. https://www.elle.com/culture/art-design/a13121006/women-in-art-december-2017/.

68. Dietrich, Joy. "Asked and Answered: Shirin Neshat." *T Magazine*, May 14, 2010. https://archive.nytimes.com/tmagazine.blogs.nytimes.com/2010/05/14/asked-and-answered-shirin-neshat/.

69. Aziz, Eimann. "Shirin Neshat: The Art of Conviction." *Whitewall*, July 16, 2012.

70. Ruiz, Christina. "Shirin Neshat." *The Gentlewoman*, no 17 (Spring/Summer 2018): 222–233. https://thegentlewoman.co.uk/library/shirin-neshat.

71. Mirlesse, Sam. "In Conversation with Shirin Neshat." *White Hot Magazine*, December 2009. https://whitehotmagazine.com/articles/in-conversation-with-shirin-neshat/1999.

72. Sert, Aysegul. "Taking Risks in Art and Politics." *The New York Times*, November 27, 2012. https://www.nytimes.com/2012/11/28/world/middleeast/28iht-letter28.html.

73. Qusaibaty, Olivia. "Interview with Shirin Neshat." *ARTiT* (Summer/Fall 2006): 56–63.

74. Neshat, Shirin. "Voice of Egypt: Shirin Neshat on Umm Kulthum." *Creative Time Reports*, November 18, 2013. https://creativetimereports.org/2013/11/18/the-voice-of-egypt-shirin-neshat-on-umm-kulthum/.

75. Neshat, Shirin. "Shirin Neshat Translates Iranian History through Art." Interview by Jeffrey Brown. PBS. June 24, 2015. Video, 5:08. https://www.pbs.org/video/shirin-neshat-translates-iranian-history-through-art-1442359136/.

76. Balaghi, Shiva. "Reflecting on Shirin Neshat's Career with the Artist's Words." *Hyperallergic*, January 13, 2020. https://hyperallergic.com/536761/shirin-neshat-broad-museum-i-will-greet-the-sun-again/.

77. Tam, Ruth. "Exiled Iranian Artist Shirin Neshat Looks at the Egyptian Revolution." *The Washington Post*, January 31, 2014. https://www.washingtonpost.com/blogs/she-the

-people/wp/2014/01/31/exiled-iranian-artist-shirin
-neshat-looks-at-the-egyptian-revolution/.

78. Sayej, Nadja. "Shirin Neshat's Unflinching Focus." *Garage*, November 10, 2019. https://garage.vice.com/en_us /article/vb5keb/shirin-neshats-unflinching-focus.

79. Neshat, Shirin. "The Other Egyptian Crisis." *Reuters*, March 5, 2014. https://www.reuters.com/article /idUK141236538520140305.

80. Cohen, Alina. "How Shirin Neshat Got Her Start as an Artist." *Artsy*, March 1, 2019. https://www.artsy.net /article/artsy-editorial-shirin-neshat-path-art-school -outcast-contemporary-art-icon.

81. Trigg, Sarah. "Seen in the Studio: Shirin Neshat." *Vulture*, December 17, 2014. https://www.vulture.com/2014/12 /seen-in-the-studio-shirin-neshat.html.

82. Bertucci, Lina. "Shirin Neshat: Eastern Values." *Flash Art 30*, no. 197 (November/December 1997): 84–87.

83. Neshat, Shirin. "Iran and Islam through a Cultural Lens." November 17, 2022. Belfer Center for Science and International Affairs, Cambridge, Massachusetts. Transcript provided courtesy of Shirin Neshat.

84. Garcia, Sandra E. "For Two Artists in Separate Fields, a Shared Desire to Be More Than One Thing." *The New York Times*. April 20, 2023. https://www.nytimes.com/2023 /04/20/t-magazine/shirin-neshat-emel-mathlouthi.html.

85. Neshat, Shirin, and Amir Ahmadi Arian. "Shirin Neshat and Amir Ahmadi Arian on *Then the Fish Swallowed Him*." The Center for Fiction. https://centerforfiction.org/interviews /shirin-neshat-and-amir-ahmadi-arian-on-then-the-fish -swallowed-him/.

86. Roxo, Alexandra. "A Conversation with Shirin Neshat." *Hammer to Nail*, November 16, 2010. https://www .hammertonail.com/interviews/a-conversation-with -shirin-neshat-women-without-men/.

87. Rexer, Lyle. "Shirin Neshat." *Photograph*, August 12, 2015. https://photographmag.com/interview/july-august-2015 -interview/.

88. Neshat, Shirin, as told to Adrianna Campbell. "500 Words." *Artforum*, May 11, 2015. https://www.gladstonegallery .com/sites/default/files/SN_Artforum_051115_0.pdf.

89. Halperin, Julia. "Shirin Neshat: cast against type." *The Art Newspaper*, May 15–17, 2015. https:// www.gladstonegallery.com/sites/default/files/SN _ArtNewspaper_15_17May2015.pdf.

90. *Ms. Magazine* 11, no. 1 (December 2000).

91. Neshat, Shirin. "Shirin Neshat to President Rouhani: 'Take Care of Your Artists.' " *Creative Time Reports*, February 3, 2014. https://creativetimereports.org/2014/02/03/shirin -neshat-iran-president-hassan-rouhani-davos-2014/.

92. Williams, Richard. "The Exotic and the Everyday." *The Guardian*, October 30, 2002. https://www.theguardian .com/artanddesign/2002/oct/31/art.artsfeatures.

93. Neshat, Shirin. TED Radio Hour. By Manoush Zomorodi. NPR, April 14, 2023. https://www.npr.org/2023/04/13 /1169675578/an-iranian-artist-on-life-in-exile.

94. Birbragher, Francine. "Shirin Neshat." *ArtNexus*. https:// www.artnexus.com/en/magazines/article-magazine -artnexus/5d630b6690cc21cf7c09e798/50/shirin-neshat.

95. Róisín, Fariha. "Shirin Neshat Has Changed the Way We See Iran, Islam and Womanhood." *Cultured*, February 8, 2019. https://www.culturedmag.com/article/2019/02/08 /shirin-neshat-broad.

96. Neshat, Shirin. "Villa Council Presents: A Lecture by Artist and Filmmaker Shirin Neshat." Getty Museum. July 28, 2022. Video, 1:05:14. https://www.youtube .com/watch?v=ss-CzqSBP-Y.

97. Various lectures from 2021–2023. Courtesy of the artist.

CHRONOLOGY

This chronology is adapted from a timeline compiled by Ed Schad for the 2020 exhibition titled *Shirin Neshat: I Will Greet the Sun Again* at the Broad Museum.

1957
March 26: Shirin Neshat is born in the religious city of Qazvin, Iran, to father, Ali, a physician, and mother, Mahin, a homemaker.

1960–74
Neshat attends elementary school in Qazvin.
She is enrolled in a Catholic high school in Tehran, though due to medical issues, she returns to Qazvin to continue high school.

1975
At the age of seventeen, Neshat is sent to the United States to finish her education, despite speaking no

English. She lives in Los Angeles with her sister, and later with a French Jewish family.

1976–77
Neshat attends University High School in Los Angeles.

1978
January: The Islamic Revolution in Iran begins.

1979
Neshat enrolls in the University of California, Berkeley. While at Berkeley, she studies under Sylvia Lark and Harold Paris.

Neshat goes to Peru on a trip with university friends. While in Lima, her Iranian passport is stolen, and she is stranded in Peru. She is eventually permitted to return to the United States by the US Embassy after the University of California, Berkeley, provides proof that she is a student.

1980

The Iran-Iraq War begins.

April 7: The United States severs diplomatic relations with Iran, effectively ending postal service between the United States and Iran. Neshat is unable to easily communicate with her family.

1981

Anti-Iran protests begin at Berkeley.

1983

Neshat graduates from Berkeley with an MFA. She moves to New York City and lives in the East Village, working various jobs. While in New York, she meets the founder of Storefront for Art and Architecture, Kyong Park, who will later become her husband. She works at Storefront as a codirector for the next ten years, encountering artists and architects such as Mel Chin, Zaha Hadid, Jean Nouvel, Kiki Smith, Alfredo Jaar, Antoni Muntadas, Dan Graham, Nam June Paik, and Mary Miss.

1985

Neshat's younger brother, Amir, emigrates to the United States with her support.

1986

July: Neshat becomes a citizen of the United States.

1988

August 20: The Iran-Iraq War ends.
November 16: Neshat marries Kyong Park.

1990

November 11: Neshat's son, Cyrus, is born.

1991

May: Neshat returns to Iran for the first time since leaving the country at seventeen.
Summer/Fall: She receives an artist residency at Henry Street Settlement on the Lower East Side.

1992

Neshat works closely with Vito Acconci and Steven
 Holl to manage construction on the new facade for
 Storefront.

June: Neshat returns to Iran for the second time since
 childhood.

Fall: She begins to work on her first wave of the *Women of
 Allah* photographs with photographer Plauto.

1993

April: *Unveiling*, Neshat's first solo exhibition, opens at
 Franklin Furnace in New York.

1994

Neshat works on a second wave of *Women of Allah* with
 photographer Cynthia Preston. The work is focused
 on the concept of martyrdom.

February 18: Neshat participates in the group exhibition
 Beyond the Borders: Art by Recent Immigrants at the Bronx
 Museum.

Later in the year, she works with photographer Larry
 Barns on additional photographs for the *Women of
 Allah* series.

1995

June: Neshat's work is included in the group exhibition
 Transculture at the Venice Biennale, curated by Fumio
 Nanjo.
August: Neshat travels to Iran for the third and final time.
September 30: *Women of Allah* opens at Annina Nosei
 Gallery in New York. Cindy Sherman is the first
 person to buy Neshat's work.

1996

Neshat's work is featured in exhibitions at Haines Gal-
 lery, San Francisco; Galleria Lucio Amelio, Naples;
 Marco Noire Contemporary Art, Turin; Centre d'art
 Contemporain, Fribourg; the Austrian Triennial
 on Photography, Graz; and the Biennale of Sydney,
 Australia.
June 20: Neshat is commissioned by Creative Time to

produce her first film, *Anchorage*, which is designed for and shown only once at the base of the Brooklyn Bridge in the Anchorage.

1997

October 5: Neshat participates in *On Life, Beauty, Translations and Other Difficulties* at the 5th International Istanbul Biennial, curated by Rosa Martínez.

Also in October, she participates in the Johannesburg Biennale, directed by Okwui Enwezor.

November: Neshat meets her future partner, Shoja Azari.

1998

Neshat and Kyong Park separate.

January: She films *Turbulent* in Manhattan over the span of two days.

Spring/Summer: Neshat travels to Morocco with Azari and filmmaker Ghasem Ebrahimian to scout a location for the video *Rapture*.

1999

Neshat's seventeen-year-old nephew, Iman, dies of
 cancer, followed closely by her father.

Articles are published in Iran against Neshat's work.

Rapture is purchased by the Whitney Museum of
 American Art.

Summer/Fall: Soliloquy is filmed in various locations
 around New York and Turkey. While filming, Neshat
 and her crew are shadowed by the Turkish govern-
 ment, and some members of the crew are arrested.

May 2: *Shirin Neshat: Rapture* opens at the Art Institute of
 Chicago.

June 13: Neshat's work is included in the Venice Bien-
 nale, and *Turbulent* wins the First International Prize.

November: *Soliloquy* debuts at the Carnegie International.

Fall/Winter: Neshat shoots *Fervor* in Morocco.

2000

Neshat is awarded the Grand Prix at the Gwangju Bien-
 nale and the Visual Art Award from the Edinburgh
 International Film Festival.

March 23: *Rapture* is exhibited as part of the Whitney
Biennial.
May 26: Neshat's work is included in the Biennale of
Sydney.

2001

Neshat's work is included in the Chicago International
Film Festival and the San Francisco International Film
Festival.
Spring: She collaborates with Philip Glass on *Passage*,
filmed in Morocco. On the same trip, she films
Possessed and *Pulse*.
September 11: The Twin Towers in New York City are
destroyed by terrorists. Neshat's son attends school
across the street, and as the tragedy unfolds, she
and Azari run on foot to pull him out of school and
bring him home.
October 5: *The Logic of the Birds* premieres at the Kitchen
in New York, commissioned by Performa and writ-
ten and filmed by Neshat, Azari, and Ebrahimian. It
is based on *The Conference of the Birds* by the poet Attar

of Nishapur. Due to the events on 9/11, the performance is altered to respond in part to the tragedy.

2002

Neshat wins the Infinity Award from the International Center of Photography in New York and has a solo exhibition at the Walker Art Center in Minneapolis.

June: She participates in *Moving Pictures* at the Guggenheim Museum.

Summer: The film *Tooba* is shot in the villages of Tiracoz and Cuilapan de Guerrero in Oaxaca, Mexico. *Tooba* is shown as a two-channel video installation at Documenta 11 in Kassel.

August: Neshat participates in the Locarno International Film Festival.

2003

Neshat is honored at the First Annual Risk Takers in the Arts Celebration awarded by the Sundance Institute in New York. She also wins the ZeroOne Award from the Universität der Künst Berlin.

May: Her work is included in the Tribeca Film Festival.

September: She participates in the ICP Triennial of Photography and Video at the International Center of Photography in New York.

Winter: Neshat begins production on the feature film *Women without Men*, an adaptation of Shahrnush Parsipur's novel of the same name. She is helped in part by the Screenwriters Laboratory of the Sundance Institute and collaborates on the screenplay with Parsipur directly. Darius Khondji, who also shot *Tooba*, is the cinematographer.

2005

Neshat visits Laos, which inspires her next video, *Game of Desire*, as well as a series of photographs.

Zarin, a second video related to the *Women without Men* project, is shot.

January: A solo exhibition of her work opens at the Hamburger Bahnhof, Museum für Gegenwart in Berlin.

July: Neshat is awarded the Hiroshima Freedom Prize from the Hiroshima City Museum of Art.

2006

April: A solo exhibition of Neshat's work opens at the Stedelijk Museum in Amsterdam.

October: Neshat wins the Dorothy and Lillian Gish Prize in New York.

2007

The remainder of *Women without Men* is filmed.

February: Neshat participates in *Lights, Camera, Action: Artists' Films for the Cinema* at the Whitney Museum in New York.

June: She joins the board of the Andy Warhol Foundation and serves an eight-year term.

2008

Neshat works on postproduction for *Women without Men*.

2009

July 1: Neshat is involved in mobilizing a three-day hunger strike in protest of human rights violations committed by the Iranian government and to

petition for the release of jailed student protesters in Iran. The protest takes place in front of the United Nations Building in New York City.

September 14: Neshat is awarded the Silver Lion for Best Director at the 66th Venice Film Festival for *Women without Men*.

2010

Neshat is named "Artist of the Decade" by the *Huffington Post*.

December: She delivers a TEDWomen lecture, "Art in Exile," in Washington, DC.

2011

The London *Financial Times* names Neshat one of the most influential women in the world.

January: She travels to Egypt with Azari to research the life of singer Oum Kulthum.

Winter: Neshat works on a series of photos titled *The Book of Kings*.

2012

September 12: *The Book of Kings* opens at Galerie Jérome de Noirmont in Paris.

2013

April 7: *Shirin Neshat* opens at the Detroit Institute of Arts. The exhibition is the first major retrospective for Neshat in the United States.

April 13: *The Book of Kings* opens at the Faurschou Foundation in Beijing.

June 6: *Written on the Body*, a survey of Neshat's work, opens at Espacio Fundación Telefónica in Madrid.

Fall: The Robert Rauschenberg Foundation commissions Neshat to shoot a series of photographs titled *Our House Is on Fire*.

Winter: Commissioned by Dior, Neshat shoots *Illusions and Mirrors* in New York.

2014

Neshat is awarded the Crystal Award by the World Economic Forum.

Toledo Contemporanea commissions her to produce
a series of nine portraits inspired by the work of
El Greco for the 400th anniversary of his death.

January 31: *Our House Is on Fire* opens at the Robert
Rauschenberg Foundation.

June 18: Neshat's video work is included in a performance of Shakespeare's *The Tempest* at the Dutch
National Opera & Ballet in Amsterdam.

September 25: *Passage through the World*, a collaboration
between Neshat, Azari, and Mohsen Namjoo, debuts
at Teatro Margherita in Bari, Italy.

November 9: *Afterwards*, a survey of Neshat's work, opens
at Mathaf: Arab Museum of Modern Art in Doha.

2015

March 24: *The Home of My Eyes* is shown at the Yarat
Contemporary Art Centre in Baku, Azerbaijan.

May 18: *Facing History*, a large survey of Neshat's work,
opens at the Hirshhorn Museum and Sculpture
Garden in Washington, DC.

2016

Neshat shoots *Roja* and *Sarah* in Pennsylvania and New York.

September: Neshat begins shooting her second feature film, *Looking for Oum Kulthum*, in Morocco.

August: Her first solo show in Africa opens at the Goodman Gallery in Johannesburg.

2017

Neshat is awarded the Praemium Imperiale Award in Tokyo alongside Mikhail Baryshnikov, El Anatsui, Rafael Moneo, and Youssou N'Dour.

May 13: *The Home of My Eyes* opens at Museo Correr in Venice, curated by Thomas Kellein.

July 1: *Shirin Neshat* opens to Kunsthalle Tübingen.

August 6: Neshat directs a production of *Aida* at the Salzburg Festival, conducted by Riccardo Muti and featuring Anna Netrebko as Aida.

September 2: *Looking for Oum Kulthum* premieres at the Toronto International Film Festival.

Winter: Neshat moves her studio from Soho in Manhattan to Bushwick in Brooklyn.

2018

January 18: *Frauen in Gesellschaft*, a survey of Neshat's work, opens at the Neue Galerie Graz in Austria.

March 20: *Looking for Oum Kulthum* is shown at the Faurschou Foundation in Copenhagen.

March 23: The *Dreamers* trilogy is shown at Kunstraum Dornbirn in Austria.

October 3: The National Portrait Gallery in London unveils Neshat's commissioned portrait of female education activist Malala Yousafzai.

November: Neshat, Azari, and Ebrahimian go on a road trip across the United States to scout locations for Neshat's third feature film, *Land of Dreams*. They settle on locations in New Mexico.

2019

May: Neshat shoots a series of photographs for *Land of Dreams*.

June: She begins filming for *Land of Dreams*.

October: *I Will Greet the Sun Again*, the largest exhibition of Neshat's work to date, opens at the Broad Museum in Los Angeles.

2021

Land of Dreams premieres at the 78th Venice Film Festival.

2022

Neshat joins protests about the death of Mahsa Amini, a twenty-two-year-old Iranian woman who died in a hospital in Tehran under suspicious circumstances, whose death resulted in one of the largest series of protests in Iran's recent history.

ACKNOWLEDGMENTS

First, my thanks go to Shirin Neshat, whose incredible voice is captured in these pages. It is a privilege to be aligned with such a thoughtful, creative mind and individual.

My sincere thanks to Giulia Theodoli and the entire studio team for their support throughout this project.

My deepest thanks to the entire team at Princeton University Press, especially Michelle Komie, Christie Henry, Terri O'Prey, Cathy Slovensky, Colleen Suljic, Laurie Schlesinger, Cathy Felgar, Jodi Price, Kathryn Stevens, Annie Miller, and Sydney Bartlett. We remain extremely grateful to PUP for their continued professionalism, encouragement, and passion for our projects together throughout the years.

Very special thanks to editorial director Fiona Graham for her invaluable research and organization of this publication.

My sincere thanks to Taliesin Thomas for her amazing assistance on this and many other projects, and to Steven

Rodríguez, Sarah Sperling, Rickey Kim, and John Pelosi for their continued support.

My thanks as well to Susan Delson for her editorial assistance and to James Snyder for his insight.

Finally, I give all my bottomless gratitude to my amazing wife, Abbey, and to my wonderful children, Justin, Ethan, Ellie, and Jonah, for their love and encouragement.

As always, I give endless love and thanks to my mother, Judith.

LARRY WARSH

Shirin Neshat is an Iranian-born artist and filmmaker living in New York. Neshat works and continues to experiment with the mediums of photography, video, and film, which she imbues with highly poetic and politically charged images and narratives that question issues of power, religion, race, gender, and the relationship between the past and present, Occident and Orient, and individual and collective through the lens of her personal experiences as an Iranian woman living in exile.

Neshat has held numerous solo exhibitions at museums internationally including the Pinakothek der Moderne, Munich (2022); Modern Art Museum of Fort Worth (2021); The Broad, Los Angeles (2020); Museo Correr, Venice, Italy (2017); Hirshhorn Museum, Washington, DC (2015); Detroit Institute of Arts (2013); Stedelijk Museum, Amsterdam (2006); Hamburger Bahnhof, Berlin (2005); the Serpentine Gallery, London (2000); and Musée d'art contemporain de Montréal (2001).

Neshat has directed three feature-length films, *Women without Men* (2009), which received the Silver Lion Award for Best Director at the 66th Venice International Film Festival; *Looking for Oum Kulthum* (2017); and, most recently,

Land of Dreams, which premiered at the Venice Film Festival (2021).

Neshat was awarded the Golden Lion Award, the First International Prize at the 48th Biennale di Venezia (1999), the Hiroshima Freedom Prize (2005), and the Dorothy and Lillian Gish Prize (2006). In 2017, she received the prestigious Praemium Imperiale Award in Tokyo.

She is represented by Gladstone Gallery in New York and Goodman Gallery in London.

Larry Warsh has been active in the art world for more than thirty years as a publisher and artist-collaborator. An early collector of Keith Haring and Jean-Michel Basquiat, Warsh was a lead organizer for the exhibition *Basquiat: The Unknown Notebooks*, which debuted at the Brooklyn Museum, New York, in 2015, and later traveled to several American museums. He has loaned artworks by Haring and Basquiat from his collection to numerous exhibitions worldwide, and he served as a curatorial consultant on *Keith Haring | Jean-Michel Basquiat: Crossing Lines* for the National Gallery of Victoria. The founder of *Museums Magazine*, Warsh has been involved in many publishing projects and is the editor of several other titles published by Princeton University Press, including *Basquiat-isms* (2019), *Haring-isms* (2020), *Futura-isms* (2021), *Abloh-isms* (2021), *Arsham-isms* (2021), *Warhol-isms* (2022), *Hirst-isms* (2022), *Pharrell-isms* (2023), and *Jean-Michel Basquiat: The Notebooks* (2017), *Keith Haring: 31 Subway Drawings*, and two books by Ai Weiwei, *Humanity* (2018) and *Weiwei-isms* (2012). Warsh has served on the board of the Getty Museum Photographs Council and was a founding member of the Basquiat Authentication Committee until its dissolution in 2012.

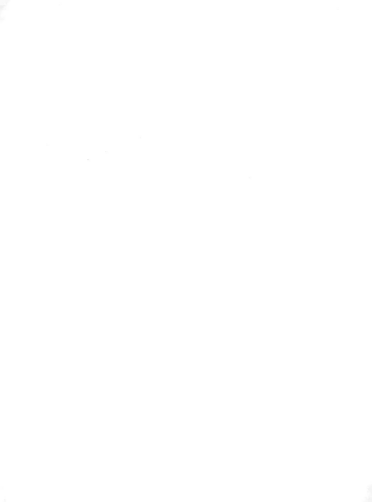

ILLUSTRATIONS

Frontispiece: Shirin Neshat © Rodolfo Martinez.

Page 108: Shirin Neshat, *Rebellious Silence*, from the *Women of Allah* series, 1994. Gelatin silver print and ink © Shirin Neshat. Courtesy of the artist and Gladstone Gallery.

ISMs

Larry Warsh, Series Editor

The ISMS series distills the voices of an exciting range of visual artists and designers into captivating, beautifully made books of quotations for a new generation of readers. In turn passionate, inspiring, humorous, witty, and challenging, these collections offer powerful statements on topics ranging from contemporary culture, politics, and race to creativity, humanity, and the role of art in the world. Books in this series are edited by Larry Warsh and published by Princeton University Press in association with No More Rulers.